DISNEY
FROZEN II
STICKER ART PUZZLES

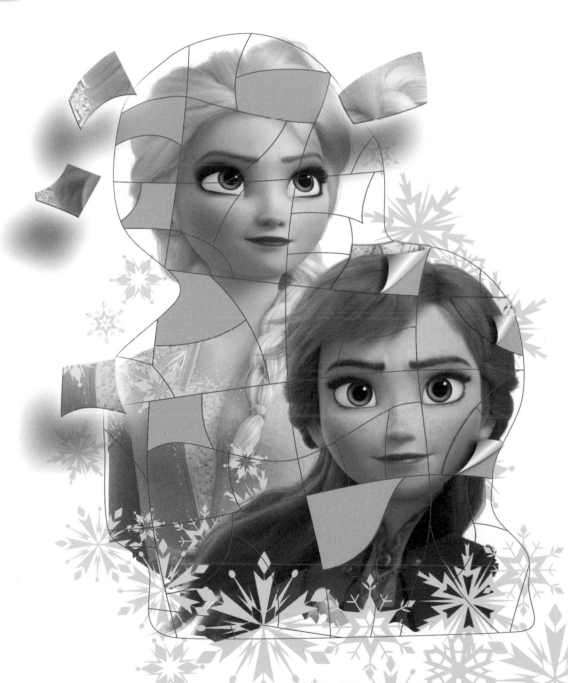

THUNDER BAY
P·R·E·S·S

San Diego, California

Thunder Bay Press
An imprint of Printers Row Publishing Group
10350 Barnes Canyon Road, Suite 100, San Diego, CA 92121
www.thunderbaybooks.com · mail@thunderbaybooks.com

Printers Row Publishing Group is a division of Readerlink Distribution Services, LLC.
Thunder Bay Press is a registered trademark of Readerlink Distribution Services, LLC.

All notations of errors or omissions should be addressed to Thunder Bay Press,
Editorial Department, at the above address.

Thunder Bay Press
Publisher: Peter Norton · Associate Publisher: Ana Parker
Senior Developmental Editor: April Farr · Developmental Editor: Diane Cain
Editor: Jessica Matteson · Senior Product Manager: Kathryn C. Dalby
Production Team: Jonathan Lopes, Rusty von Dyl

Produced by Judy O Productions, Inc.
Author: Gina Gold

ISBN: 978-1-68412-909-6

Printed, manufactured, and assembled in Dongguan, China.

24 23 22 21 20 3 4 5 6 7

Contents

Introduction

Frozen and *Frozen 2* are epic tales about love and eternal friendship between sisters. Follow Elsa and Anna from their childhood in the magical, snow-filled Great Hall in Arendelle Castle to a new adventure, as the young women travel north to discover the truth about the Enchanted Forest. These fifteen challenging sticker puzzles, with more than one hundred pieces each, feature Anna, Elsa, Olaf, Kristoff, Sven, and the trolls. The images recall Anna's journey to North Mountain in *Frozen* and Elsa's quest to return the four elements of nature to Arendelle in *Frozen 2*. As you work on the puzzles, watch as iconic moments from both films appear before your eyes, piece by piece.

Instructions

Use Your Magic to Solve the Puzzles, Piece by Piece
On each puzzle you'll find a grid. Use the stickers to reveal Elsa, Anna, and all of your favorite friends of Arendelle as they venture beyond the gates and into the storm.

How to Solve the Puzzles
Each sticker puzzle features a framed "outline" of the image you will piece together. Enclosed in the outline are geometric spaces that offer hints where each puzzle goes. Watch as the *Frozen* and *Frozen 2* scenes and characters come to life.

The stickers start on page 52. You can either remove the perforated sticker page or use the cover flaps to mark your place. Apply each sticker to its corresponding shape on the outline. The stickers can be moved in case you make a mistake. If you need a hint, numbered solutions begin on page 36.

DO YOU WANT TO BUILD A SNOWMAN?

Young Princesses Anna and Elsa lived in a large castle in the kingdom of Arendelle. One night, young Anna couldn't sleep because the spectacular Northern Lights lit up the sky. Anna convinced a sleepy Elsa to get out of bed by making her an irresistible offer: "Do you want to build a snowman?" Elsa let her sister drag her downstairs to an empty Great Hall. There, Anna begged Elsa to summon her magical powers. Young Elsa rolled her hands one over the other then unleashed her power to create snow and ice. Suddenly, snow fell inside the room! Next, Elsa froze the floor into a skating rink. Sparkling snowflakes settled in drifts on the icy floor, and the sisters began to build a snowman.

"Do the magic! Do the magic!"

—Young Anna

The girls piled one big ball of snow on top of the other, then Elsa added a carrot nose and twig arms. She introduced their creation in a silly voice, "Hi, I'm Olaf, and I love warm hugs." Anna was overjoyed as she ran to the snowman and threw her arms around him.

"I love you, Olaf!" she said.

Next, Elsa created huge snowdrifts. But as Anna bounded across them, climbing higher and higher, Elsa accidentally struck her with her magic! From that day on, the King and Queen encouraged Elsa to conceal her feelings and her magic because they feared others would harm her if they learned of her powers.

Stickers on page 53. Solution on page 37.

THE GATES OPEN!

Anna was bored and lonesome without her sister's company. She entertained herself by riding her bicycle through the castle halls and even talking to paintings.

When she and her sister were teenagers, the King and Queen took a long voyage and perished at sea. When Princess Elsa came of age, it was time for her coronation. The gates were thrown open, and people flooded into

"It's coronation day!"
—Anna

Arendelle from near and far to greet the new queen. It was a momentous occasion, especially for Anna. It was only one day, but Anna planned to live life to the fullest while she could. She took in the spectacular view of the harbor and rejoiced at the thought of a castle full of light, music, and dance. Most of all, she wanted to meet people! She might even meet her true love. Anna sang and danced through the halls. She turned to a suit of armor to practice shaking hands. He was a perfect stand-in for the people she'd meet. In her excitement, Anna pulled the knight's armored arm right off. But she wasn't worried about that or anything else because she was ready for all the wonderful things the day would bring.

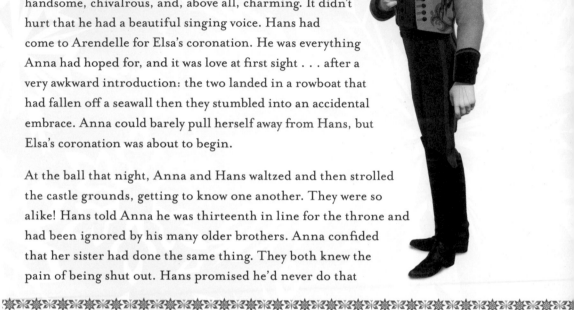

ANNA MEETS PRINCE HANS

Prince Hans of Southern Isles was perfect. He was
handsome, chivalrous, and, above all, charming. It didn't
hurt that he had a beautiful singing voice. Hans had
come to Arendelle for Elsa's coronation. He was everything
Anna had hoped for, and it was love at first sight . . . after a
very awkward introduction: the two landed in a rowboat that
had fallen off a seawall then they stumbled into an accidental
embrace. Anna could barely pull herself away from Hans, but
Elsa's coronation was about to begin.

At the ball that night, Anna and Hans waltzed and then strolled
the castle grounds, getting to know one another. They were so
alike! Hans told Anna he was thirteenth in line for the throne and
had been ignored by his many older brothers. Anna confided
that her sister had done the same thing. They both knew the
pain of being shut out. Hans promised he'd never do that

"I would never shut you out."

—Prince Hans

to Anna. They danced and sang under a full moon.
Finally, Hans dropped to one knee.

"Can I say something crazy?" he
asked. "Will you marry me?"

"Can I say something
even crazier?" Anna
asked. "Yes!"

Anna was sure she had
found true love, but Elsa
would not let her marry a man she had just met. Anna
couldn't believe it. She thought she'd finally made
a connection with her sister on this special day, but
now they seemed farther apart than ever.

ELSA'S ICE PALACE

After Anna told Elsa she planned to marry Prince Hans, a total stranger, Elsa was so overwhelmed she accidentally blasted Arendelle with an eternal winter, shocking the townspeople and dignitaries from surrounding kingdoms. Her secret was out! The coronation was a disaster. Elsa ran away from Arendelle, toward the North Mountain.

"Yes, I'm alone. But I'm alone and free!"

—Elsa

Alone on the snowy peak, the young queen finally felt free. She could let go of what she'd been taught about holding herself back and use the full force of her powers. Elsa threw one cold blast after another and built a towering ice palace where she could live out her life in solitude. Elsa was no longer willing to hide who she was, so she embraced her new life far from anyone she might hurt.

Back in Arendelle, Anna finally understood that her sister, Elsa, had shunned her all those years out of love. Anna set out to find her atop the cold, forbidding mountain.

Stickers on page 60. Solution on page 40.

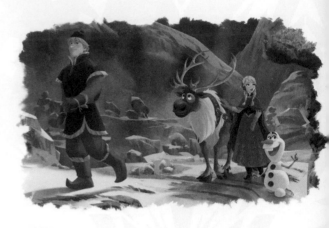

TROLLS: THE LOVE EXPERTS

Hiding in plain sight as moss-covered rocks, the happy, warm-hearted mountain dwellers rolled over to reveal themselves as trolls. Kristoff the ice harvester was their adopted son—specifically, the son of Bulda and Cliff. The young mountain man and his reindeer, Sven, spent most of their time alone, working beneath

"Okay then . . . Meet my family."

—*Kristoff*

the ethereal glow of the Northern Lights. That was, until Princess Anna hired Kristoff to help her find her sister Elsa on the North Mountain. Kristoff reluctantly agreed.

With the help of the magical snowman Olaf, Kristoff, Anna, and Sven arrived safely at Elsa's ice palace. But the queen lost control of her powers and injured her sister once again. Anna's hair was turning white; her strength was waning. Kristoff rushed her to the trolls for help. But his adoptive family was so taken with the beautiful girl they peppered Kristoff with questions about her before he could even say why he'd come. As love experts, they recognized something special between them. Kristoff said that they'd gotten it all wrong; Anna was engaged to someone else. But the trolls had already started their wedding.

Suddenly, in the midst of the festivities, Anna collapsed. Grand Pabbie examined the princess. He said Elsa had put ice in her heart, and he warned Anna that she was in grave danger. Only "an act of true love" could save her, he said.

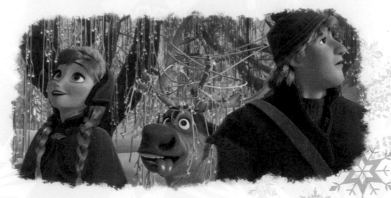

SVEN: A DEVOTED FRIEND

This loyal reindeer had been at Kristoff's side ever since they were very young. The carrot-loving sidekick had an enormous rack of antlers and was great at pulling a sleigh loaded down with huge blocks of ice. Despite his size, Sven had a warm heart and a gentle and expressive face. Kristoff turned to Sven as

"Give me a snack ... please."

—*Kristoff imitating Sven*

his conscience when he needed to work things out. And, in turn, Kristoff could seemingly read Sven's mind, and often voiced the reindeer's thoughts for him. The pair was so close, Kristoff was pretty sure reindeer were far better than people.

Sven had fun getting his antlers tangled in icy vines, he loved to bound through the snow, and he usually found Olaf's carrot nose irresistible. But Sven would also save the day over and over again, carrying Kristoff and Anna away from a pack of wolves, leaping across an abyss, and escaping a terrifying snow monster. And soon, Sven would truly prove he was a hero.

Stickers on page 64. Solution on page 42.

OLAF'S SUMMER FANTASY

Young Elsa used her powers to fill the Great Hall of Arendelle Castle with ice and snow. Then she rolled up three big snowballs, added a carrot nose and twigs for arms, and introduced her creation to her little sister as Olaf, the snowman who loves warm hugs.

When Elsa was older, her powers brought Olaf to life. Eventually, the snowman with a naive fascination with summer would become part of Anna's newfound family. Olaf shared his vision of life in warm weather with Anna, Kristoff, and Sven. He dreamed of skipping through meadows, lounging in a hot tub, and vacationing on a tropical island. He saw himself on a beach holding an iced tea in his twiggy hand with only an umbrella to protect himself from the blazing sun.

"I've always loved the idea of summer and sun and all things hot."

—Olaf

After Olaf finished describing his ill-conceived fantasy of a balmy future on a tropical island, Kristoff turned to Anna and said, "I'm gonna tell him." Anna furrowed her brow, elbowed Kristoff, and said, "Don't you dare!"

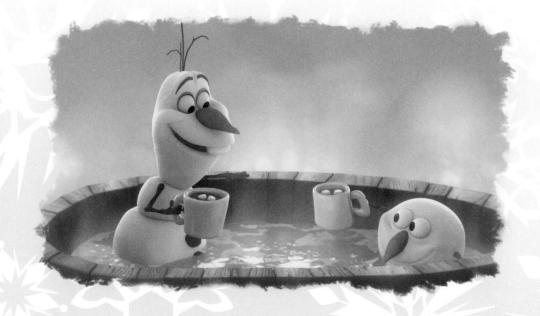

Stickers on page 68. Solution on page 44.

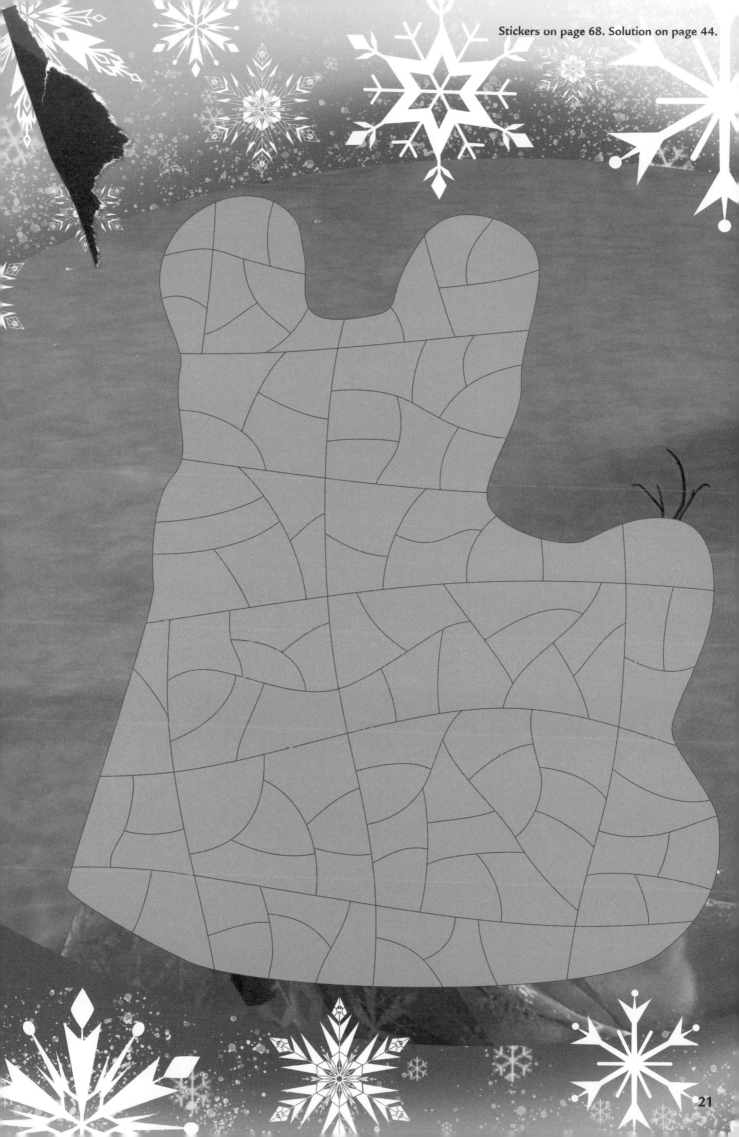

THE CALLING

It was autumn. Three years and two months had passed since the events in *Frozen*. Elsa had honed her skills as queen, but she'd been hearing a mysterious voice, a kulning sound that no one else could hear. And it seemed to be calling her away from her kingdom. She tried to ignore the voice calling her north, but it was irresistible.

One night, Elsa followed the voice outside. She was so curious— was it coming from someone magical, like her? Then she had a strange thought. She'd use her magic to send snow out into the air. To her amazement, beautiful images emanated from her fingertips and floated around her. Then, a sudden blast of her powers sent a massive shock wave across the fjord. Moisture in the air froze into beautiful crystals that fell to the ground. The earth shook, the winds died, and the torches went out. The fountains in Arendelle ran dry. All four elements—earth, wind, fire, and water—had disappeared from the kingdom!

The trolls rolled into town. Grand Pabbie said Elsa's magic had awakened the spirits in the Enchanted Forest. Elsa and Anna had heard about the forest and the spirits when they were small. Their father, King Agnarr, had said the spirits once lived peacefully in the forest, but when fighting broke out

"It kept calling to me, and then my magic came alive in this new way."

—*Elsa*

between the Arendellians and the Northuldra, the spirits were enraged and had turned against them all. Their father had escaped, but an impenetrable mist surrounded the forest, trapping everyone else inside. The spirits had disappeared that day, but Grand Pabbie said Elsa's powers reawakened them. He told Elsa she had to go to the Enchanted Forest, and he told Anna she needed to go with her sister.

Stickers on page 69. Solution on page 45.

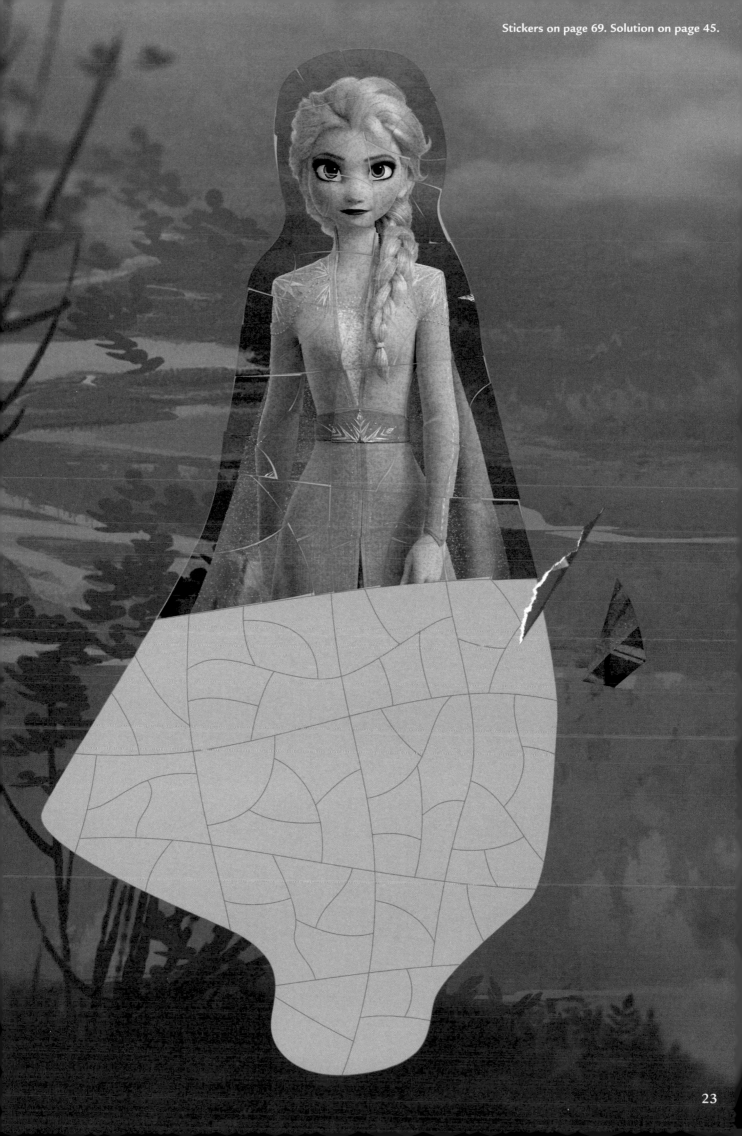

A JOURNEY NORTH

Anna delighted in her life in Arendelle. She adored her sister, Elsa, as well as her found family—Kristoff, Olaf, and Sven. After the four elements—earth, wind, fire, and water—disappeared from the kingdom, Grand Pabbie told Anna she must accompany Elsa to the Enchanted Forest and keep her safe. It would be a perilous journey to the north, but Anna was brave and determined to protect her sister. She'd promised Elsa she wouldn't let anything happen to her. Kristoff, Olaf, and Sven joined the sisters on their quest to find this mystical land.

After a long trek, the group came upon a wall of mist. Finally, they saw the Enchanted Forest, a stunning place where four large monoliths stood, each bearing a symbol for one of the elements. What Anna didn't know as she traveled through the forest was that Kristoff was planning a surprise. He was concealing a ring and was ready to propose to her! But his timing was never right. Something or someone kept getting in his way.

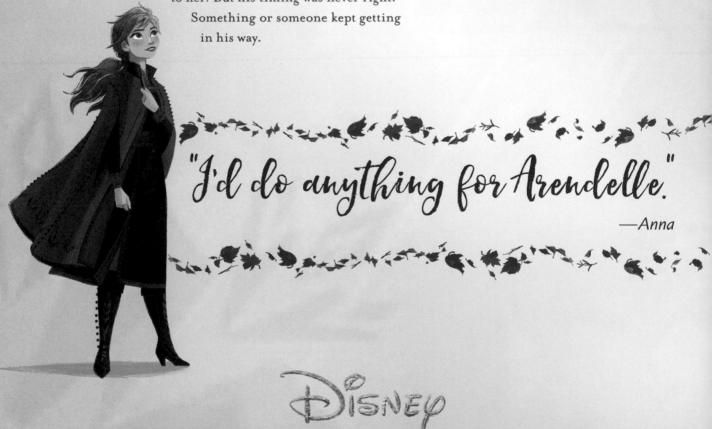

"I'd do anything for Arendelle."

—*Anna*

DISNEY FROZEN II

24

A JOURNEY NORTH

Anna delighted in her life in
Arendelle. She adored her sister,
Elsa, as well as her found family—
Kristoff, Olaf, and Sven. After the
four elements—earth, wind, fire, and
water—disappeared from the kingdom,
Grand Pabbie told Anna she must accompany
Elsa to the Enchanted Forest and keep her safe. It
would be a perilous journey to the north, but Anna
was brave and determined to protect her sister. She'd
promised Elsa she wouldn't let anything happen to
her. Kristoff, Olaf, and Sven joined the sisters on
their quest to find this mystical land.

After a long trek, the group came upon a wall of mist.
Finally, they saw the Enchanted Forest, a stunning
place where four large monoliths stood, each bearing
a symbol for one of the elements. What Anna
didn't know as she traveled through the forest
was that Kristoff was planning a surprise. He
was concealing a ring and was ready to propose
to her! But his timing was never right.
Something or someone kept getting
in his way.

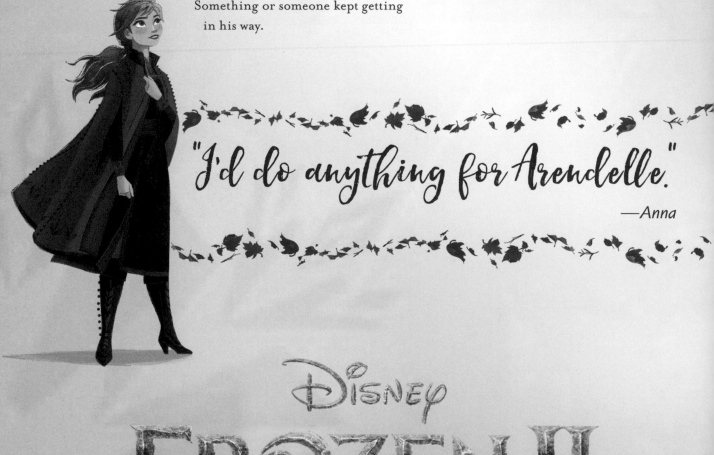

"I'd do anything for Arendelle."

—*Anna*

DISNEY

FROZEN II

THE ENCHANTED FOREST

Once in the Enchanted Forest, Anna, Elsa, and their friends became separated and found themselves under a thick canopy of trees. Soon they came upon a group of long-lost soldiers. Some were Arendellians; others were Northuldra. Anna remembered Mattias, a loyal lieutenant to her

"It's magic. I can feel it."

—Elsa

father. She had seen his picture on a wall at the castle. He explained that he and people from both of the kingdoms had been trapped in the mist for over thirty years.

When the soldiers saw Elsa's magic in action, they grew uneasy. Magic had led to their captivity. Still, once they observed the full force of Elsa's powers, they believed she was the one to finally break the forest's curse and free them all. The people surrounded her. Anna could see that Elsa was overwhelmed by the prospect of so much responsibility, so she moved in to protect her sister from the crowd.

DISNEY
FROZEN II

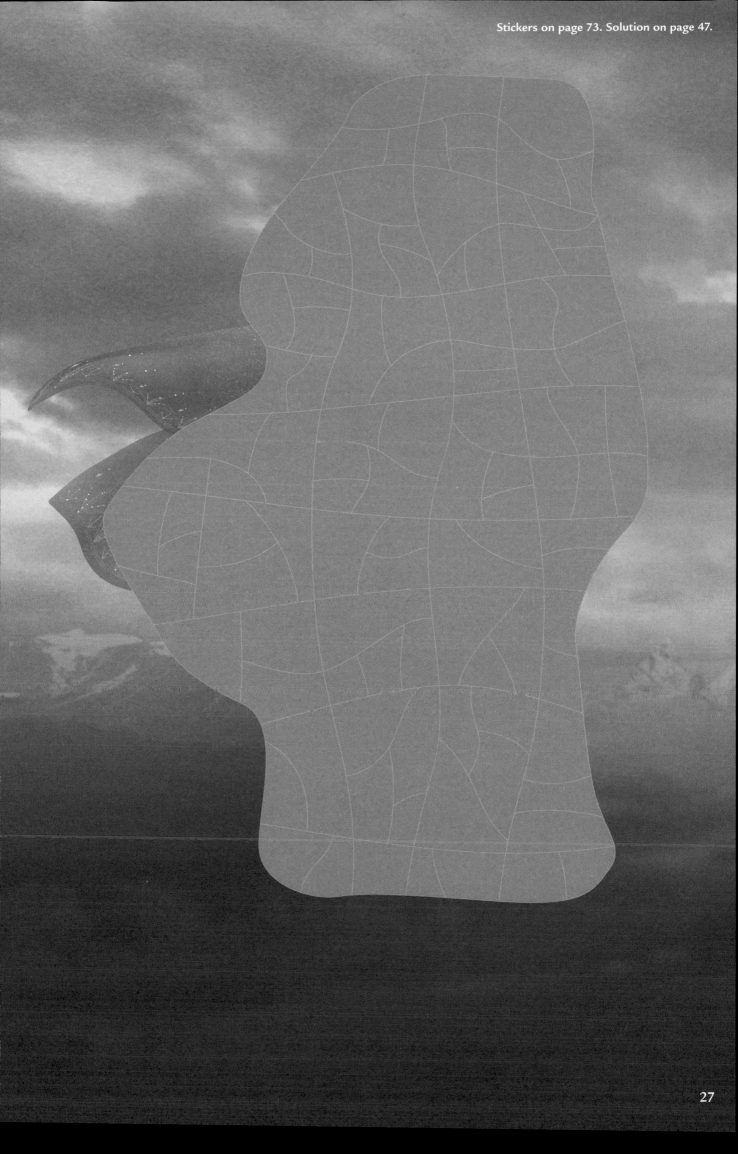

WATER HAS MEMORY

Olaf had become a beloved member of his
found family, so he was eager to join Elsa
and the others on their journey to find
the Enchanted Forest. Olaf the snowman
experienced autumn as if for the first time.
He was enthralled by all life had to
offer and beheld the world around
him with a new sense of curiosity.

The group arrived at the edge of the lush region,
but Olaf wandered off into the woods.
There, he frolicked in a pile of leaves
and ran through moss. He laughed at
the wind as it whipped past him, and
then he stared at his reflection in a brook. But
under the water, past his image, he saw a different face
reflect. The Water Nokk was staring back at him! Olaf screamed and ran back to
his friends. This was a spirit of nature the king had talked about in his stories.

*"Oh, yeah. Water has memory.
It's my favorite of the unproven theories."*

—Olaf

When Olaf returned, he and his friends were swept up by the Wind Spirit. Elsa
was forced to use her magic in new ways, and when they were released, amazing
sculptures of ice surrounded them. The images depicted memories from a
distant past. Olaf offered a theory. He surmised that water has memory and
that Elsa's sculptures were re-creations of events that had occurred in the
Enchanted Forest years before. Even Elsa was amazed that her powers had
allowed them to look back into the past.

DISNEY
FROZEN II

28

SOJOURNERS

Elsa and Anna had heard about the spirits of the Enchanted Forest from their father. The king's stories seemed like fantasies, but when the girls arrived in the forest, they quickly realized the spirits he'd spoken of were very real and were showing them what had happened there many years ago.

Elsa continued to hear the unsettling call, the kulning, beckoning her, urging her to travel north. It led Anna and her sister to a dry riverbank where their parents' shipwreck had settled into the mud. Elsa yearned to know how they had perished. So she used her powers to extract memory of the events from moisture locked in the ship's boards. Her lacy ice sculptures revealed that the king and queen had been headed north so they could finally understand Elsa's powers.

"They look like moments in time."

—*Elsa*

Had they died because of her? Elsa was wracked with guilt. She refused to allow her parents' deaths to have been in vain. So Elsa set out to finish what her parents had started. She was going to travel across the sea to learn the truth about the magic she was born with.

Disney

FROZEN II

A NEW FAMILY

Anna and Kristoff joined Elsa on her trip to the Enchanted Forest so they could protect her. But Kristoff also had something on his mind. He wanted to propose to Anna. He even brought along a ring he'd picked out for her. Kristoff had grown close to Anna during their quest to find Elsa in her ice palace, and they'd only grown closer since. Kristoff waited all those years to propose, not because he doubted his love for Anna but because he remembered what a disaster her brief engagement to the two-faced Prince Hans had been. He wanted to earn Anna's trust and for everything to be perfect. But when Anna left him

"This is it. Everyone ready?"

—Kristoff

behind to accompany Elsa as she continued on her journey northward, Kristoff was forlorn. Had they grown apart? Proposing to Anna during this journey to the Enchanted Forest—rife with the spirits of fire, water, wind, and even Earth Giants—was proving far more difficult than Kristoff had imagined.

DISNEY
FROZEN II

DESTINY AWAITS

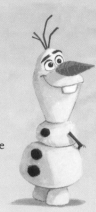

Elsa's quest to restore the elements to Arendelle turned into an adventure that was far more exciting—and treacherous—than she could have imagined. It began with a call, a kulning that was drawing her north. With the urging of the trolls, she headed for the Enchanted Forest, where the answers would lie. Anna, Kristoff, Sven, and Olaf went along to protect Elsa and give her the strength she'd need to save the kingdom. Together they all learned exactly what happened in the Enchanted Forest so many years ago. The

"May you all find your futures."

—Grand Pabbie

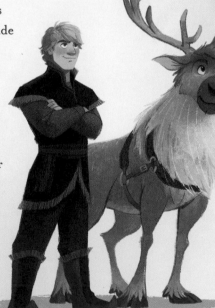

girls had only heard tales of the battles that had taken place there and the spirits that had ended them. And Elsa and Anna would learn the true fate of their parents and of the sacrifice they had made for their daughter who was destined to be queen.

But ultimately, as the voice kept calling Elsa, she had to continue on alone. And in a spectacular confrontation with the Water Nokk, Elsa was about to understand just how mighty her powers were and why she had been born with them.

Solutions

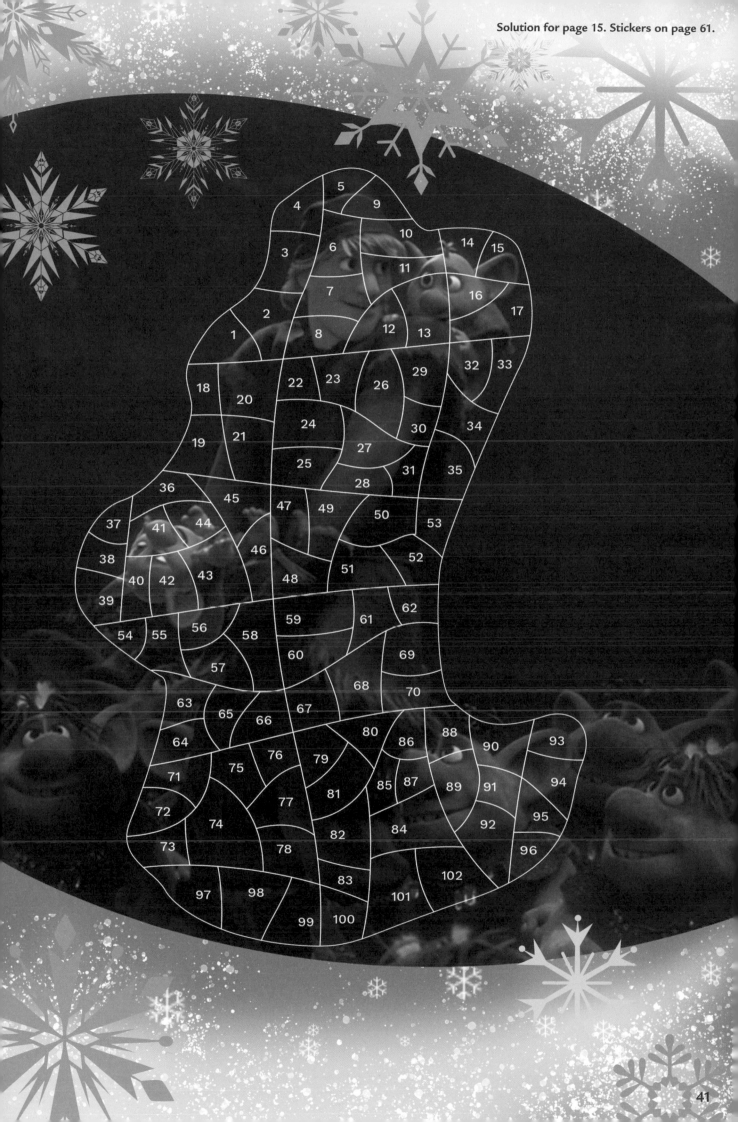

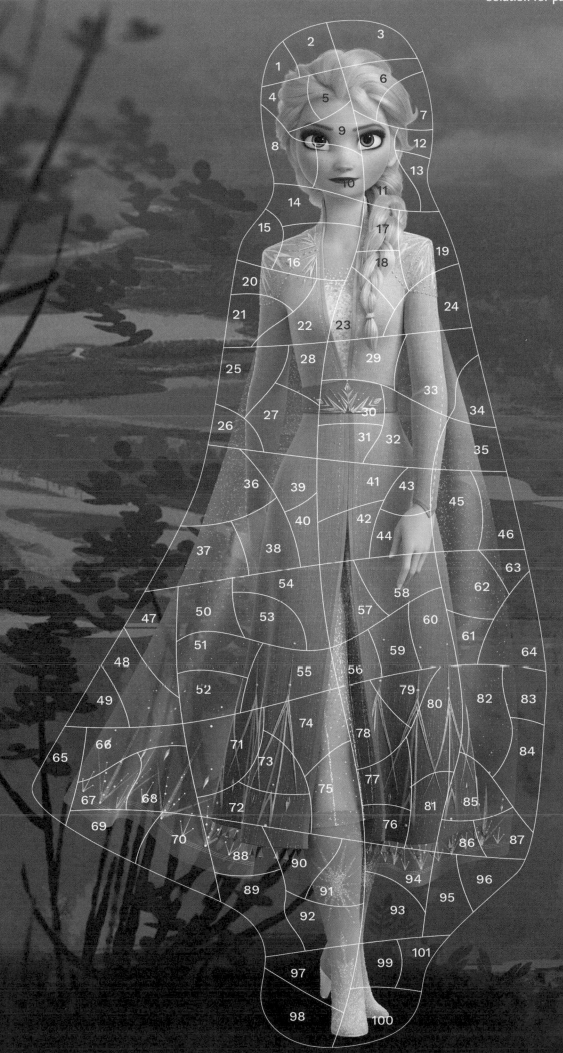

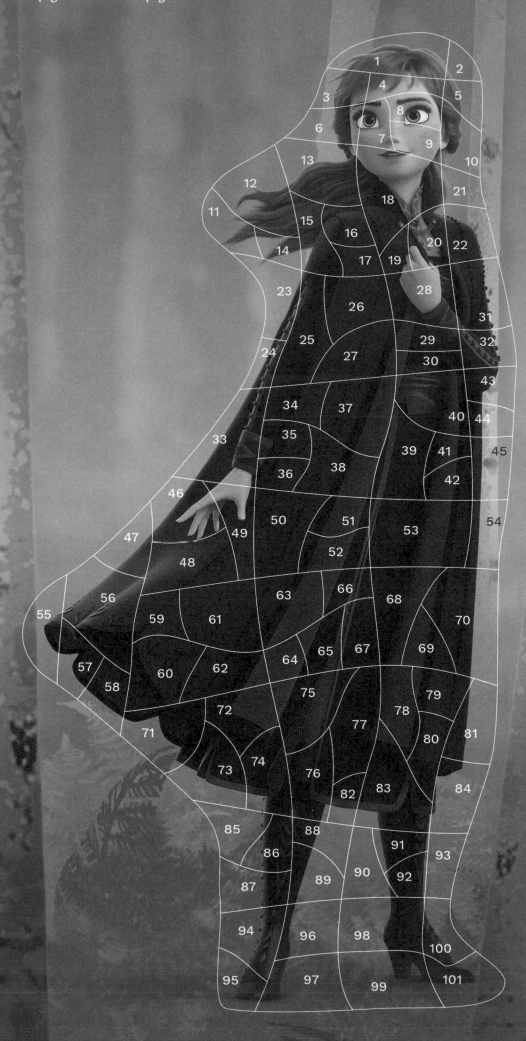

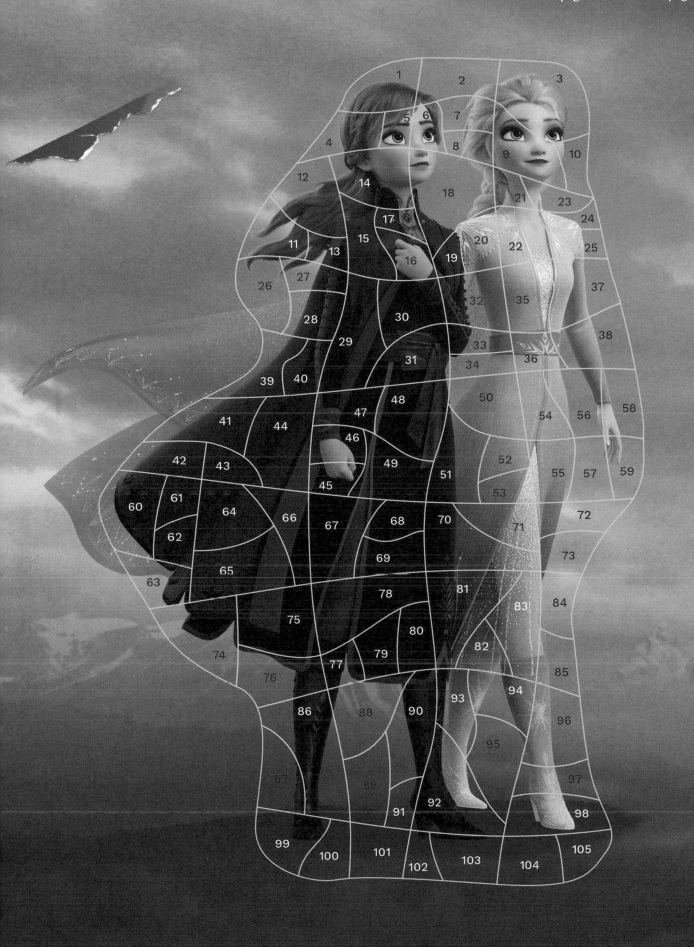

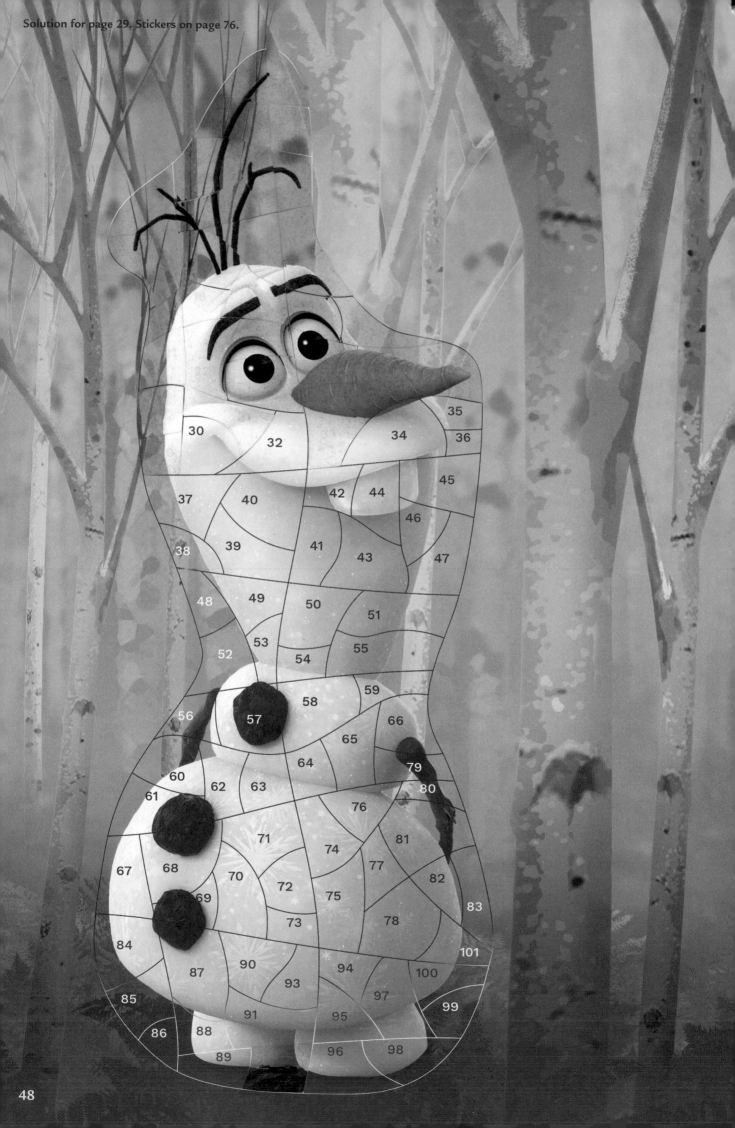

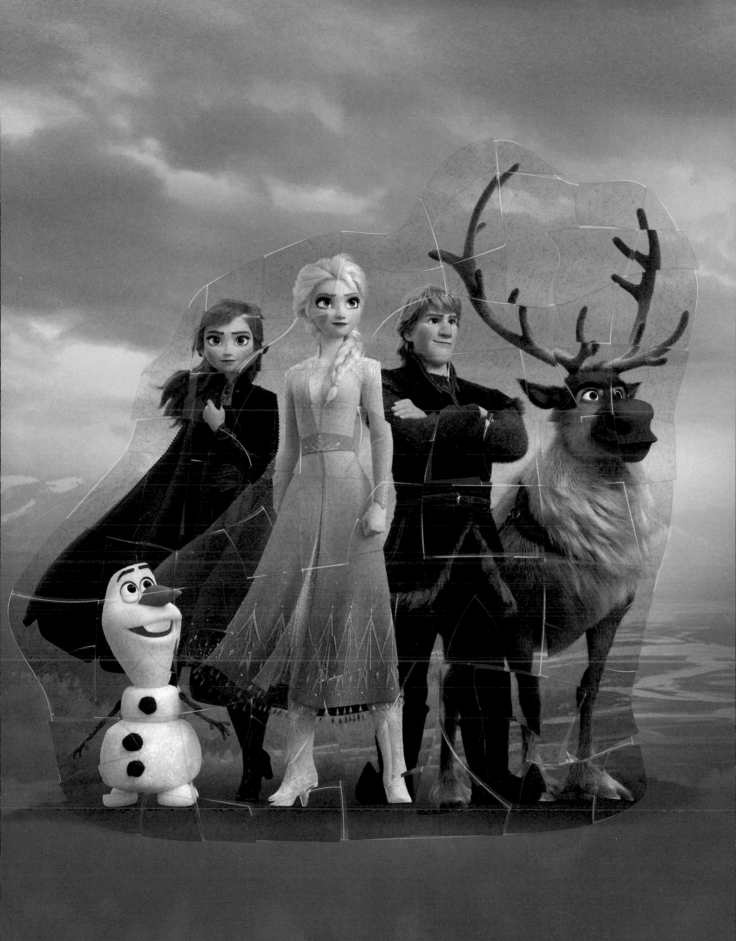

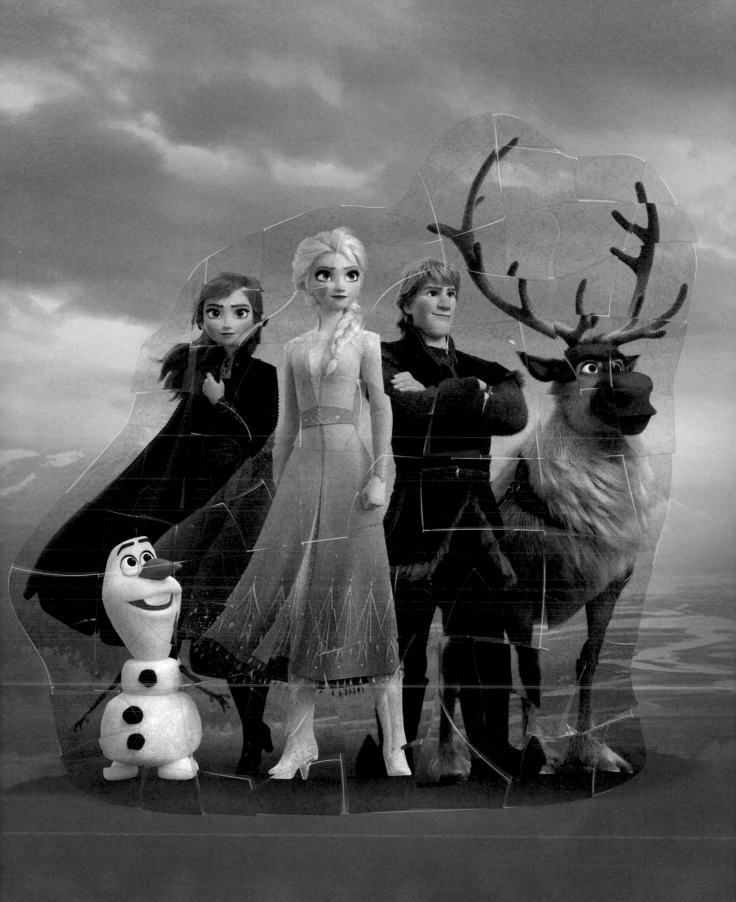

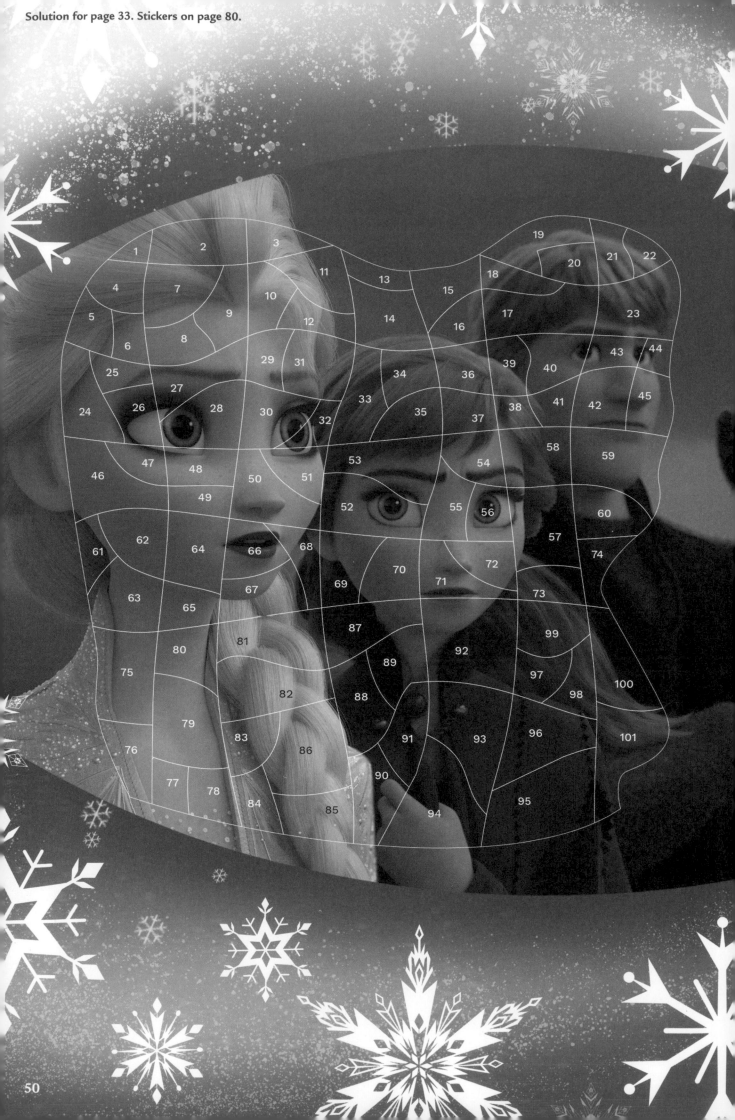

Stickers

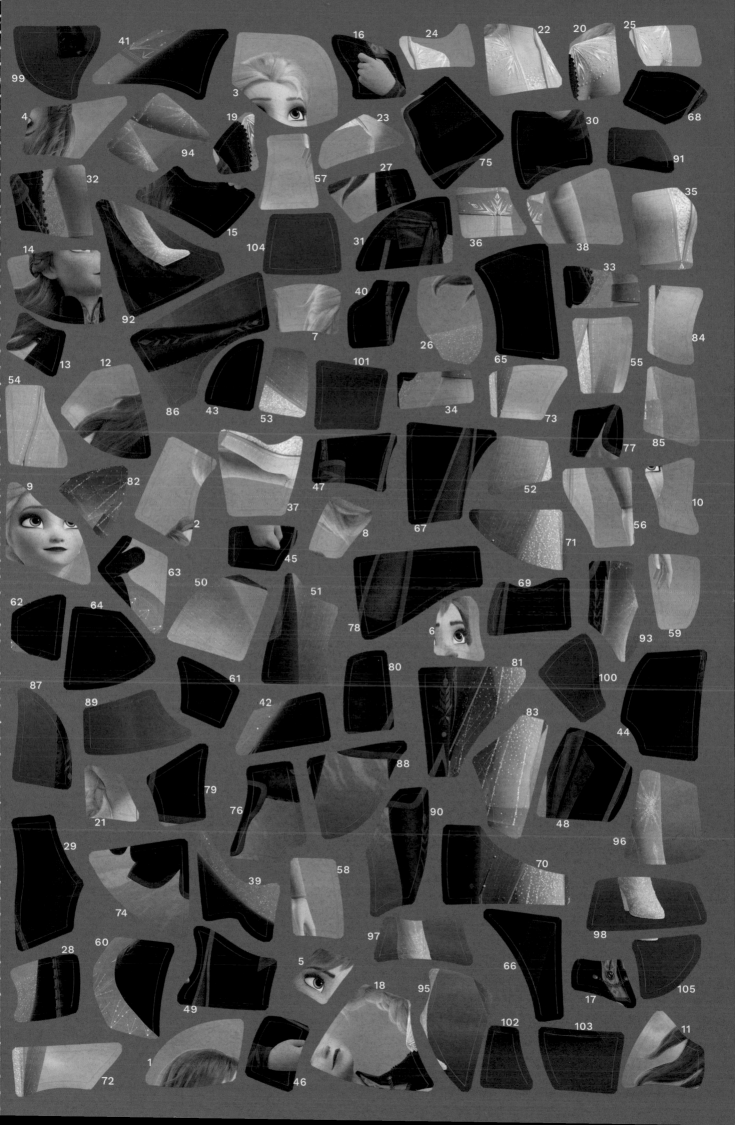